Cinderella

or The Little Glass Slipper

HARPER
DESIGN
An Imprint of HarperCollins Publishers

CHARLES PERRAULT

Illustrations by Camille Rose Garcia

erella

OR

The Little Glass Slipper

Once upon time...

a

there was a nobleman who took for a second wife the haughtiest and proudest woman ever known. She had two daughters of the same temperament, who resembled her in everything. The nobleman, on his side, had a daughter of unmatchable gentleness, goodness, and beauty. She inherited these qualities from her mother, who had been the best creature in the world.

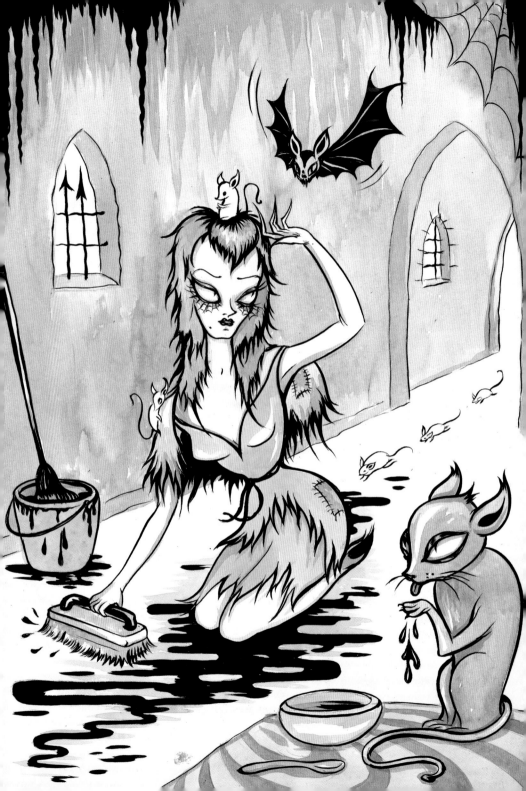

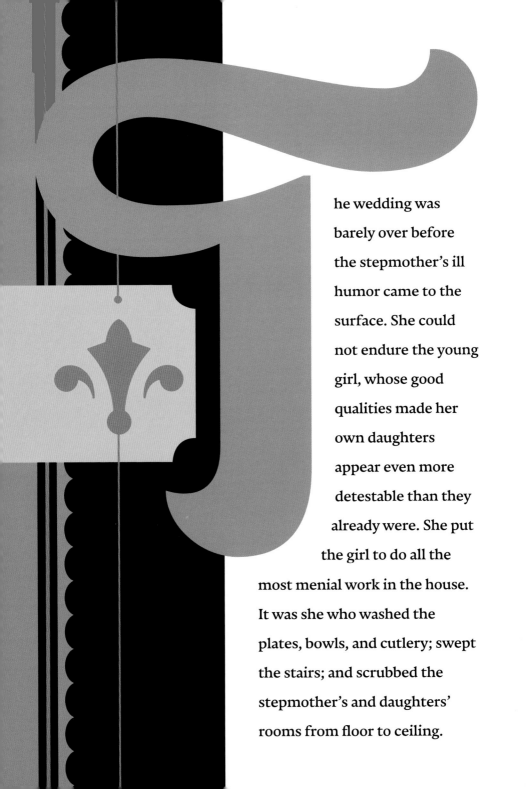

he wedding was barely over before the stepmother's ill humor came to the surface. She could not endure the young girl, whose good qualities made her own daughters appear even more detestable than they already were. She put the girl to do all the most menial work in the house. It was she who washed the plates, bowls, and cutlery; swept the stairs; and scrubbed the stepmother's and daughters' rooms from floor to ceiling.

She

slept on a wretched straw mattress in a garret at the top of the house, while her sisters occupied rooms with inlaid floors, the most fashionable beds, and mirrors in which they could see themselves from head to toe. The poor girl bore everything with patience and did not dare complain to her father, who would only have scolded her, as he was entirely governed by his wife.

When she had done her work, the girl was in the habit of going into the chimney corner and sitting among the cinders. This resulted in her nickname, Cindertail, which was bestowed upon her by her elder stepsister and used by the full household.

The younger stepsister, though, who was not quite so rude as her sister, chose to call the girl

Cinderella.

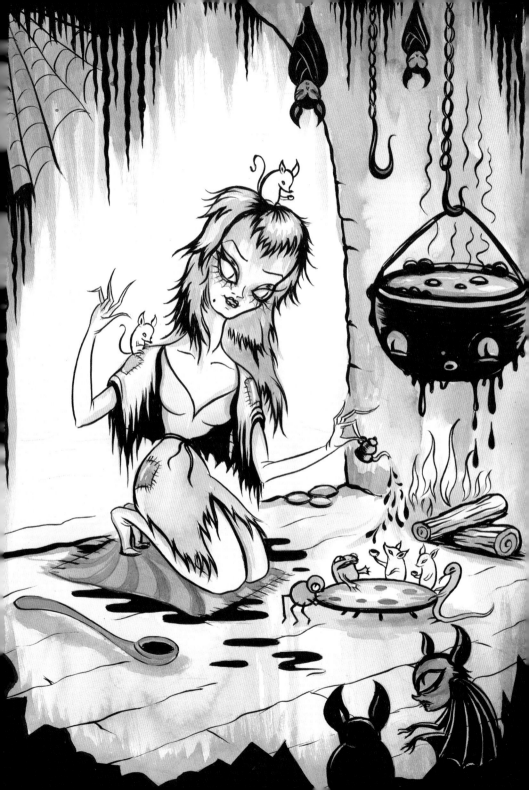

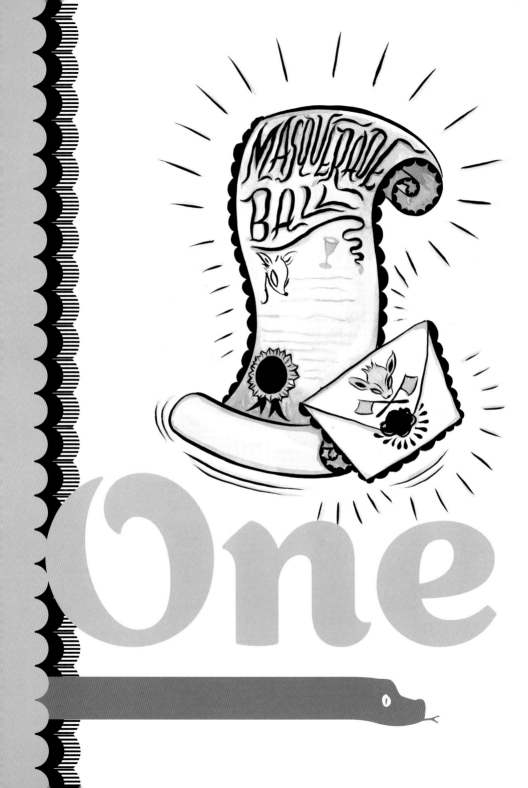

Nevertheless, even in her shabby clothes, Cinderella was still a thousand times more beautiful than her stepsisters, although they were always dressed magnificently.

day

it happened that the king's son decided to give a two-evening ball, to which he invited everyone of position in the land.

The two step-sisters

were among those who received an invitation, for they wore the finest clothes and hats, always making a great show wherever they went. The invitation delighted them so greatly that they did nothing but busy themselves in choosing the most becoming gowns and headdresses. For poor Cinderella, the ball presented a new mortification: she would have to spend hours scrubbing and ironing her sisters' fine linen and goffering their ruffles.

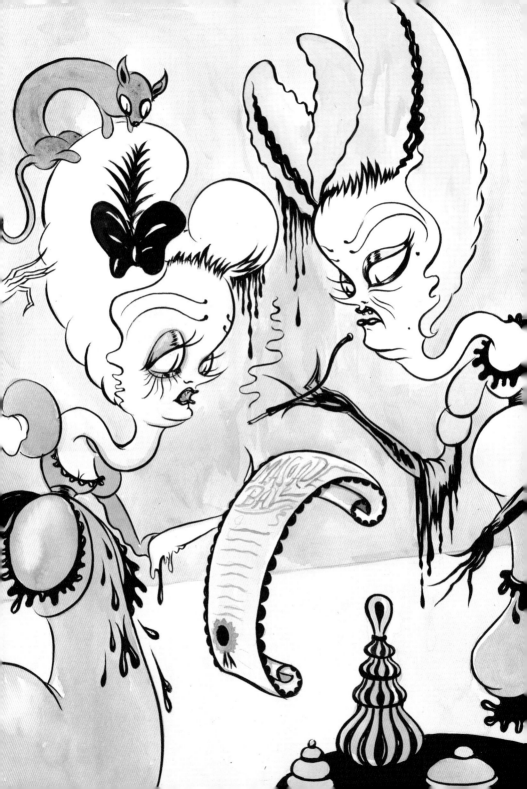

Neither stepsister talked of anything but the style in which she was to be dressed.

"I," said the eldest, "will wear my red velvet dress and my English point-lace trimmings."

"I," said the youngest, "shall only wear my usual petticoat; but, to make up for that, I shall put on my gold-flowered cloak and my clasp of diamonds, which are none of the least valuable."

They sent for a first-rate milliner so that their head-dresses might be made to fashion, and they had elaborately embroidered gloves made to order from the best maker. They called on Cinderella to give them her opinion on every matter of their appearance, for her taste was excellent. She not only gave them the best advice, but even offered to dress their hair for them.

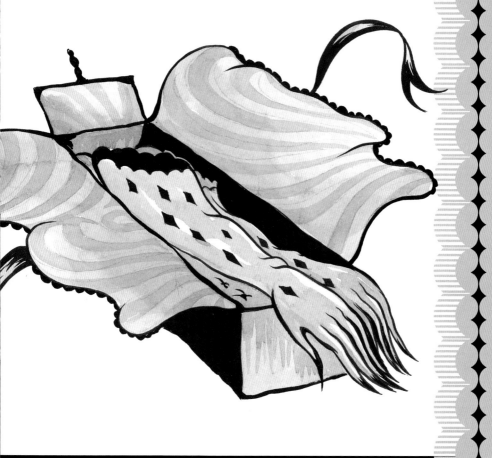

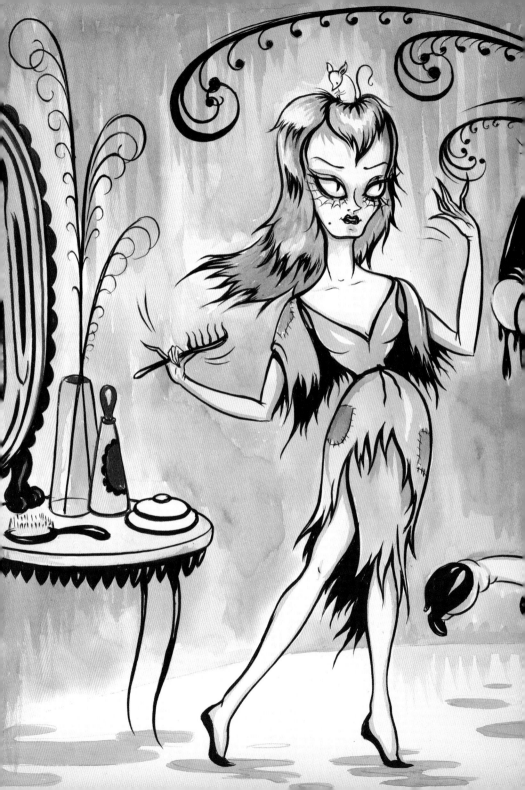

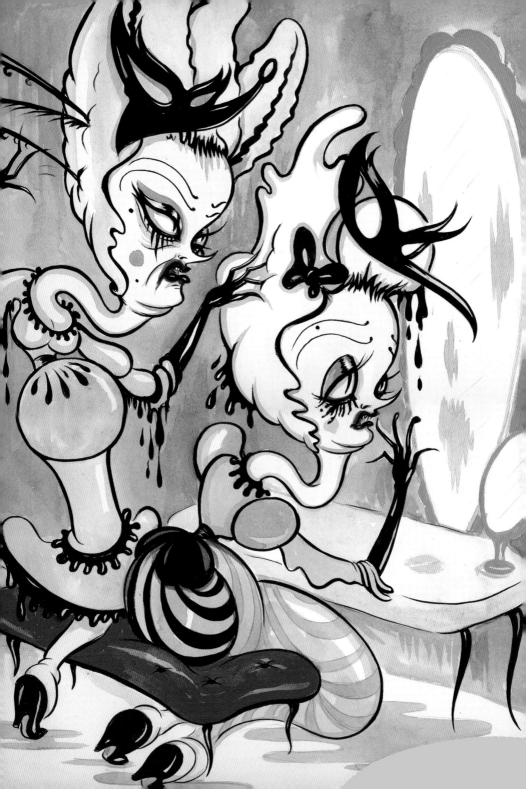

On the day of the first ball, as Cinderella was tending to the stepsisters' tresses, the elder sister asked, "Cinderella, should you be very glad to go to the festivities?"

"Alas! You only make fun of me; such a thing would not be suitable for me at all."

"You are right," she sneered, "they would indeed laugh to see a

Cinder at the

tail
ball!"

Of course,

any other poor soul would have dressed her cruel sisters' hair awry, but Cinderella had a good disposition and arranged it perfectly for both of them. The sisters had eaten nothing for nearly two days, so transported were they with joy, yet more than a dozen laces were broken in making their waists as small as possible. The pair continually gaped and posed before their looking-glasses all day long.

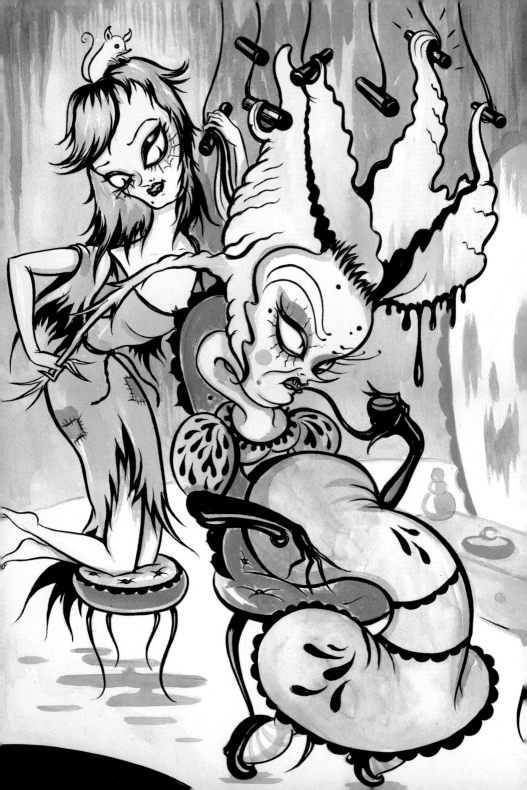

At last, evening arrived. The sisters set off for the palace, and Cinderella watched the coach that transported them away for as long as she could. When the coach was finally out of sight, she began to cry.

"Whatever is the matter, my child?"

Cinderella turned around to see a magnificently dressed lady with a sweet face.

"I am your fairy god-mother,"

she said. "What makes you weep so?"

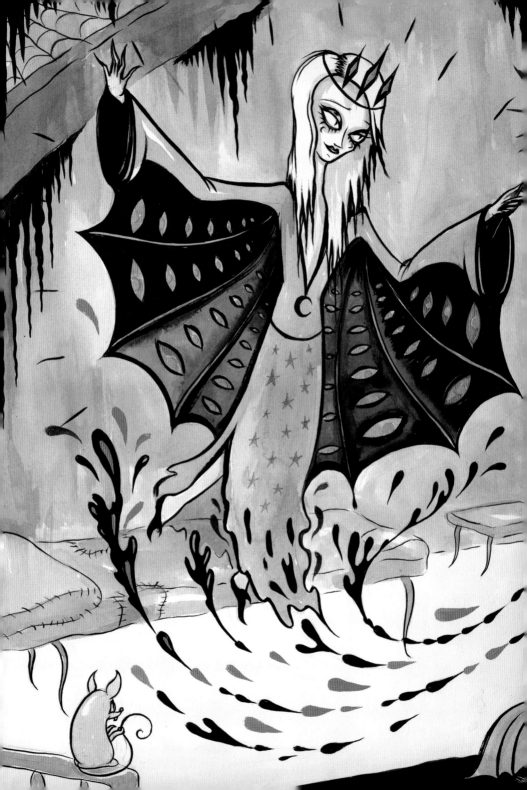

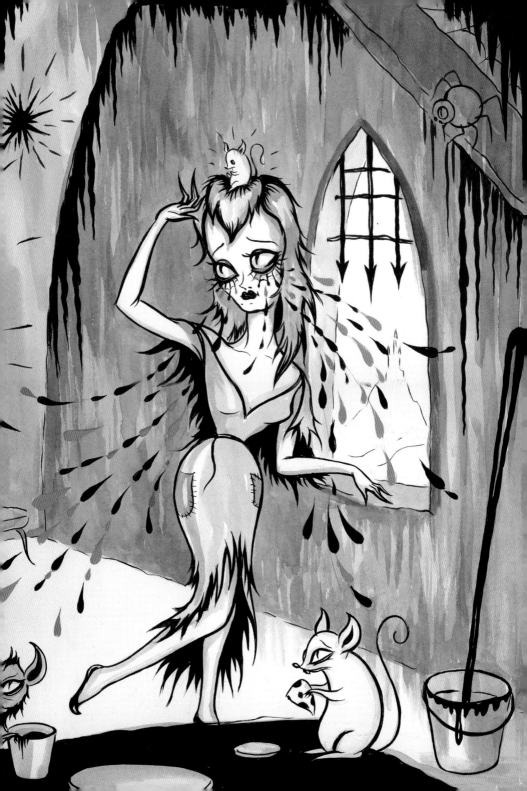

"I should so like—I should so like—" Cinderella sobbed so violently that she could not finish her sentence.

"You would so like to go to the ball, is not that it?"

"Alas! Yes," said Cinderella, sighing.

"Well, if you will be a good girl, I will undertake that you shall. Go into the garden and bring me a pumpkin."

Cinderella—wondering how a pumpkin could enable her to go to the ball—went outside at once, gathered the finest one she could find, and brought it to her fairy godmother. Her fairy godmother took the pumpkin and scooped out all the flesh and pulp. Having left nothing but the rind, she struck it with her wand, immediately

Changing
✦ it into a

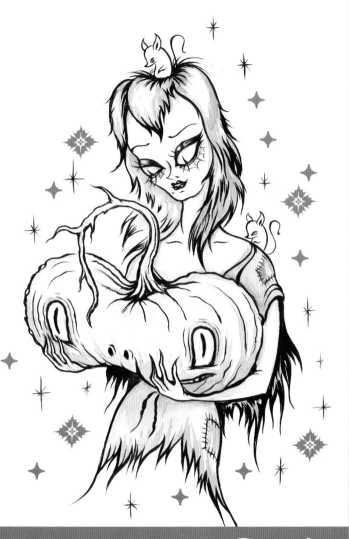

beautiful coach, gilt all over.

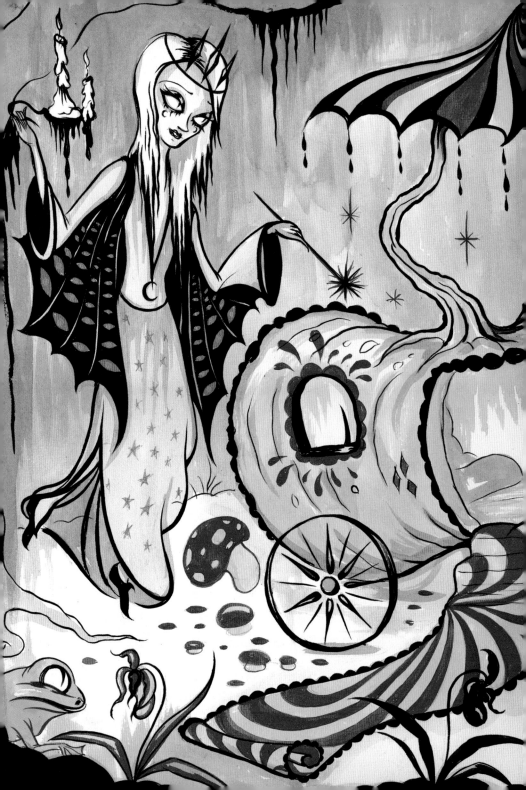

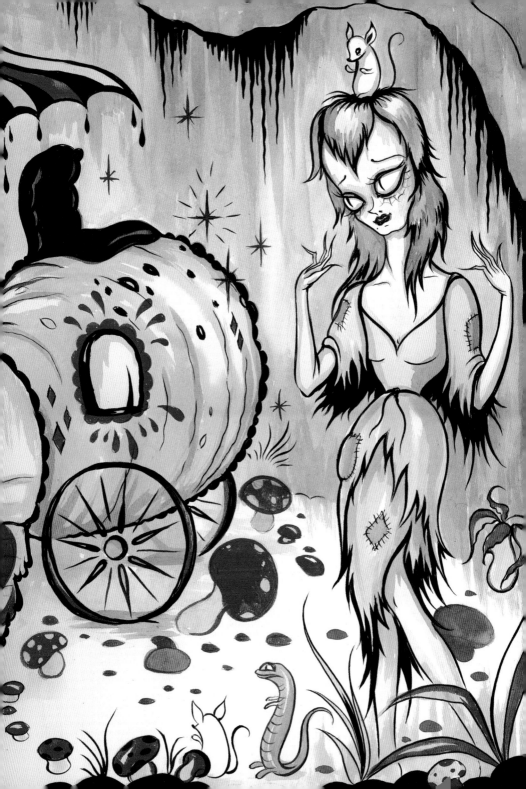

She then went and looked into the mousetrap, where she found six mice, all alive. She told Cinderella to lift the door of the mousetrap a little, and to each mouse, as it ran out, she gave a tap with her wand. Each creature was immediately transformed into a fine horse, and with the last there stood ready a handsome train of six horses with beautiful dappled mouse-gray coats.

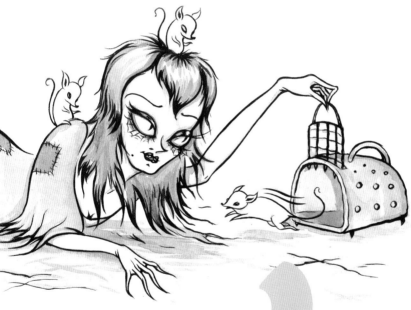

abracadabra
bracadabra
racadabra
acadabra
cadabra
adabra
dabra
abra
bra
ra
a

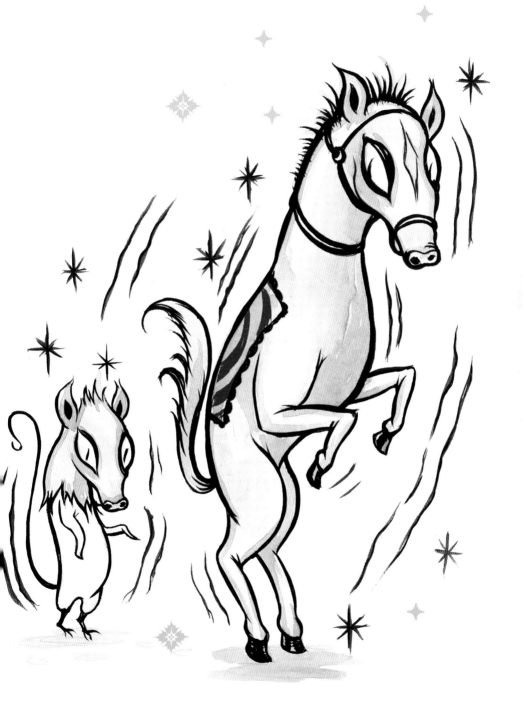

When the fairy godmother was in some difficulty as to what she could turn into a coachman, Cinderella said, "I will go and see if there is a rat in the rattrap; if so,

we will make a coach-man of him."

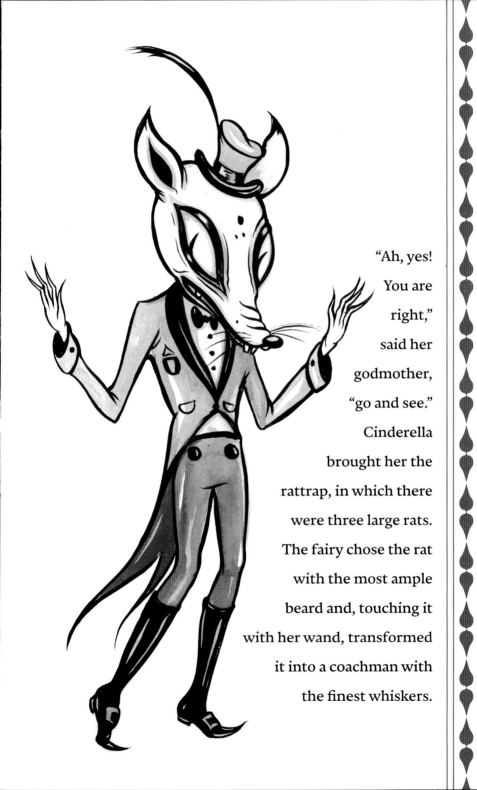

"Ah, yes! You are right," said her godmother, "go and see." Cinderella brought her the rattrap, in which there were three large rats. The fairy chose the rat with the most ample beard and, touching it with her wand, transformed it into a coachman with the finest whiskers.

She then said, "Go again into the garden, and there, behind the watering pot, you will find six lizards. Bring them to me." Cinderella had no sooner brought the lizards than her godmother changed them into

six foot

with their liveries all covered with lace. They immediately jumped up behind the coach and hung on to it as gracefully as if they had done nothing else all their lives.

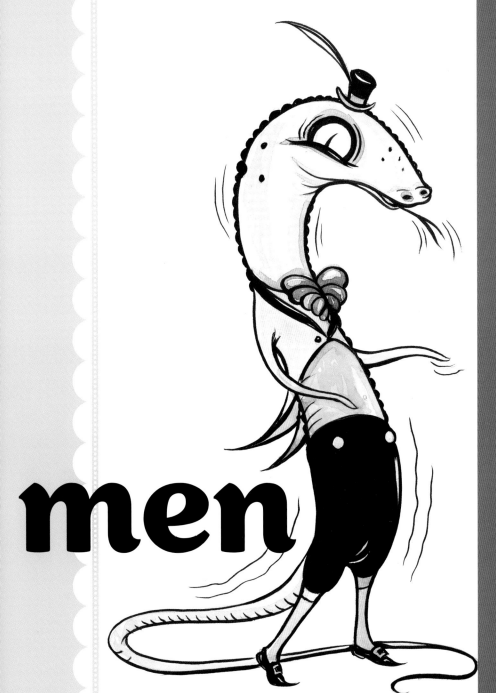

men

The fairy godmother then said to Cinderella, "Well, there is something in which to go to the ball; are you not well pleased?"

"Yes," Cinderella said, "but am I to go in these dirty old clothes?"

Her godmother touched Cinderella lightly with her wand, and in the same instant her ragged dress was transformed into a stunning gown of

covered with precious stones all over. She then handed Cinderella a pair of glass slippers, the prettiest in the world.

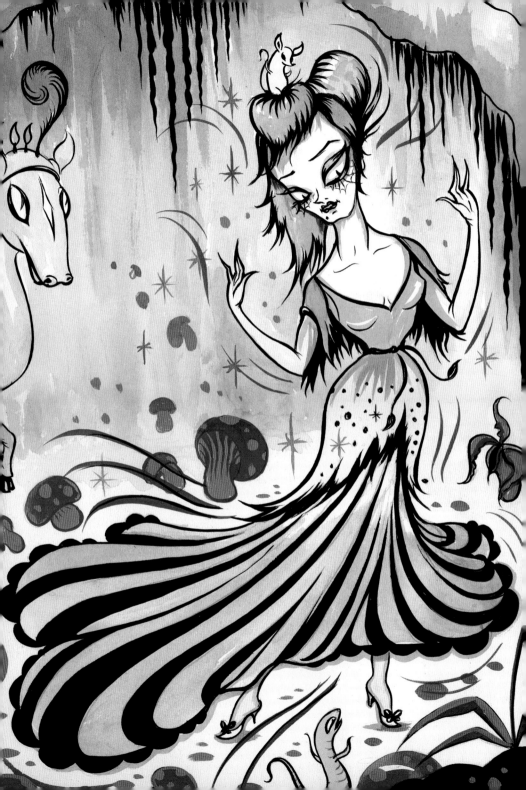

Thus attired, Cinderella got into the coach. Her godmother then warned her: "Above all things,

do stay mid

If you remain at the ball a minute longer, your coach will again become a pumpkin; your horses, mice; your footmen, lizards; and your clothes, your old rags."

not past night.

Cinderella promised her godmother that she would not fail to leave the ball before midnight. The coach then drove off, and Cinderella was out of her mind with joy.

At the palace,

the prince, who had been informed that a grand princess whom no one of the court seemed to recognize had arrived, ran to receive her. He took Cinderella's hand and helped her out of the coach. He then escorted her into a great hall, where the guests were assembled in all their finery. Her arrival summoned a complete silence: the dancing stopped and the fiddlers ceased to play, so engaged was everyone in gazing upon the unknown princess's astounding beauty.

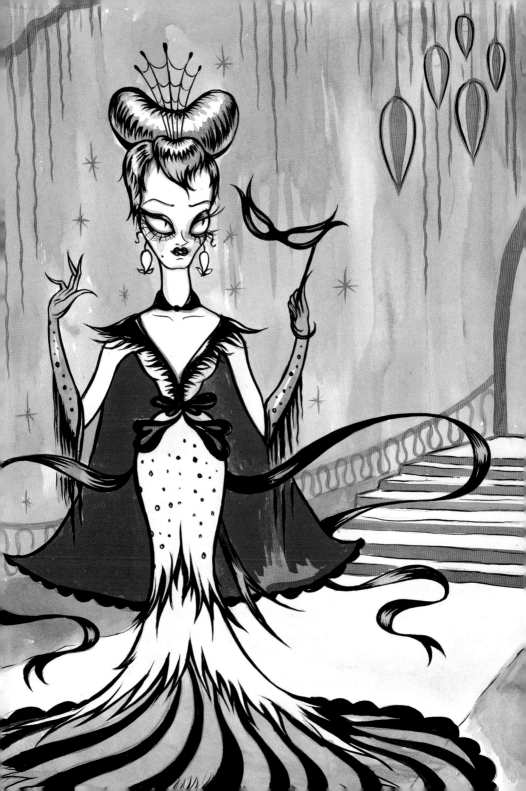

There was not a sound, except for the whispered murmur of

"Oh!

The king himself, old as he was, could not take his eyes from her and observed to the queen that it had been a long time since he had seen one so lovely and amiable. All the ladies were intently occupied in examining Cinderella's headdress and clothes, that they might order some like them the very next day, provided that they might be able to find materials as costly and workpeople sufficiently clever to make them up.

How
lovely
she is!"

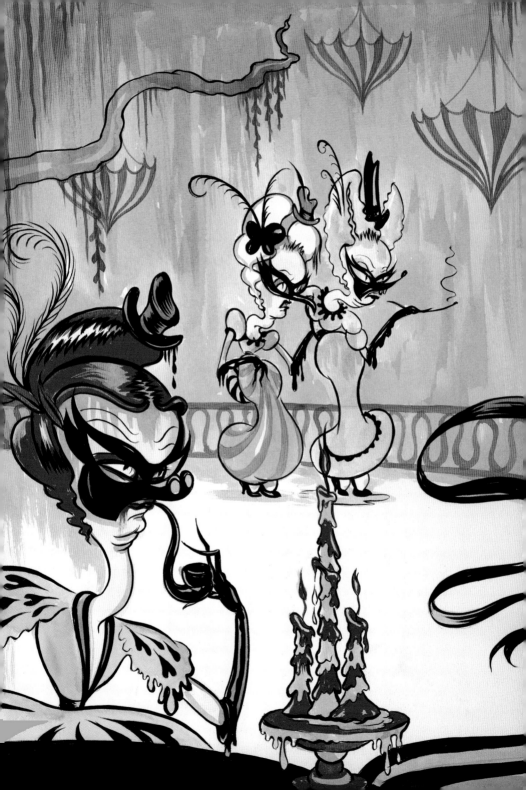

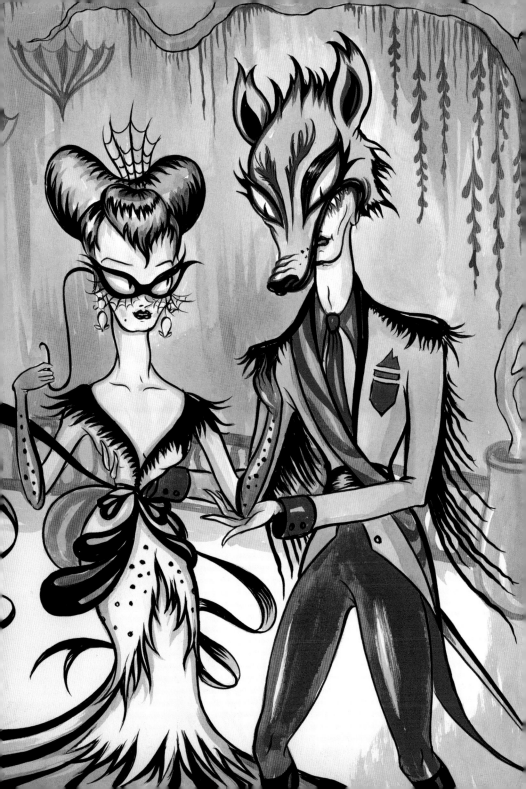

The prince conducted Cinderella to the most honorable seat in the hall, and then led her out to dance. She danced so gracefully that everybody admired her all the more. After the dancing, a very grand supper was served, but the prince could not eat a morsel, so absorbed was he in the contemplation of her beauty. Cinderella seated herself beside her sisters, and showed them a thousand civilities. She shared with them the oranges and citrons that the prince had given her, a gesture at which they were greatly surprised, for she appeared a perfect stranger to them.

While they were thus talking together, Cinderella heard the clock strike quarter to twelve. At once she made a profound curtsy to the company and left as quickly as she could.

tick~

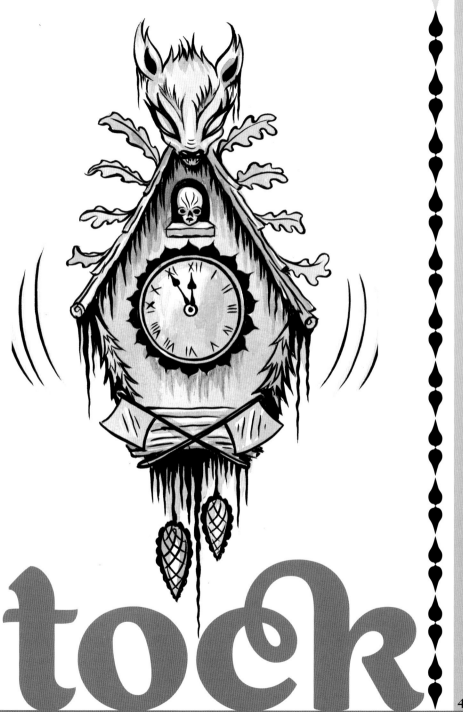

tock

As soon as Cinderella had reached home, she went to her chamber, only to find her fairy godmother waiting for her.

"Thank you so much for sending me to the ball, dearest godmother," she said.

"It was my great pleasure."

"Only—" Cinderella began.

"Yes?"

"Forgive me—" she stammered. "It's just that I wish to go to the ball tomorrow as well.

The prince
May

has invited me. I go?"

"Of course you shall," the fairy godmother said.

"Now, dearest girl, tell me all that passed at the

palace."

Cinderella told her all in intricate detail, and was speaking of the wonderful dancing and delicious supper when there was a hard knock at the door. Her fairy godmother quickly vanished, and Cinderella opened the door.

There stood the stepsisters.

"How late you are!" said she to them, yawning, rubbing her eyes, and then stretching herself as if she had been sleeping, although she had had no inclination to sleep since she parted from them at the ball.

"If you had been at the ball," said one of her sisters, "you would not have been weary of it. There came to it

the most beautiful princess,

the most beautiful ever seen; she paid us many attentions, and gave us oranges and citrons."

Cinderella was beside deli

She asked them the name of the princess, but they replied that nobody knew her. They said the prince was much puzzled about it and that he would give everything in the world to know who she was.

herself with ght.

Cinderella smiled, and said, "She was very lovely, then? How fortunate you are! Could not I get a sight of her? Alas!" She asked the eldest stepsister, "Could you not lend me the yellow gown you wear every day?"

"Truly! I like that! Lend one's gown to a dirty Cindertail like you!

I should be mad indeed!"

Of course, Cinderella fully expected this refusal and secretly rejoiced at it, for she knew she would be attending the ball in an even finer gown the next evening.

The next day the sisters went again to the palace. Cinderella did, too, even more splendidly dressed than before. The prince never left her side or ceased saying tender things to her all evening. The evening passed very pleasantly, so much so that Cinderella forgot her godmother's warning. When she heard the clock begin to strike twelve she was most surprised, for she thought surely it was not yet eleven.

She rose quickly and fled lightly as a fawn.

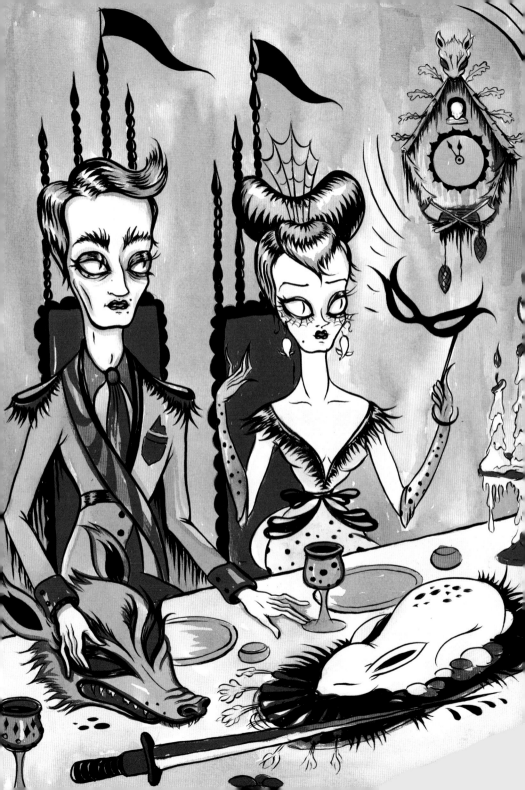

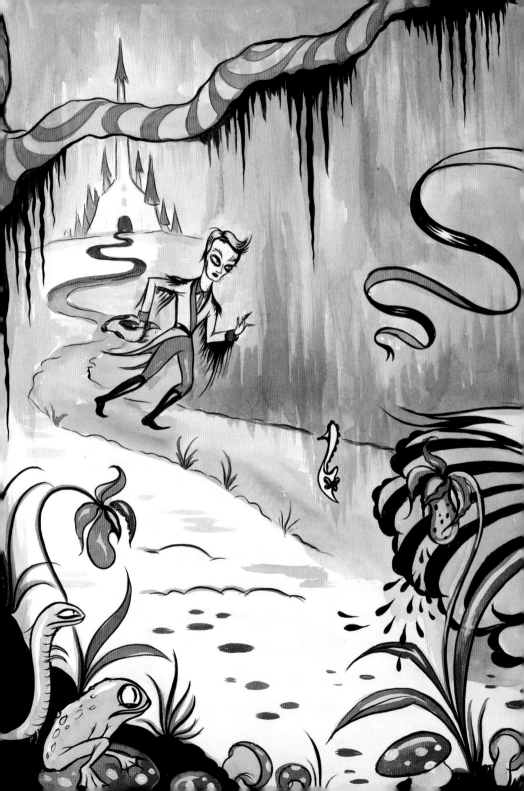

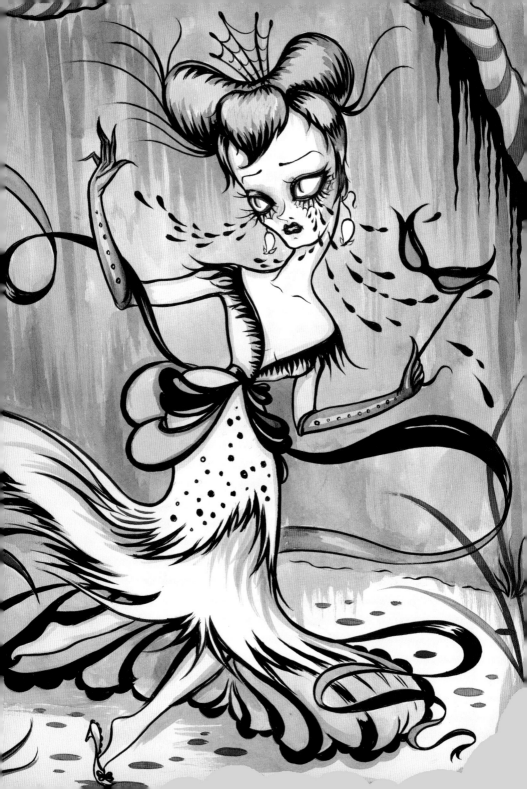

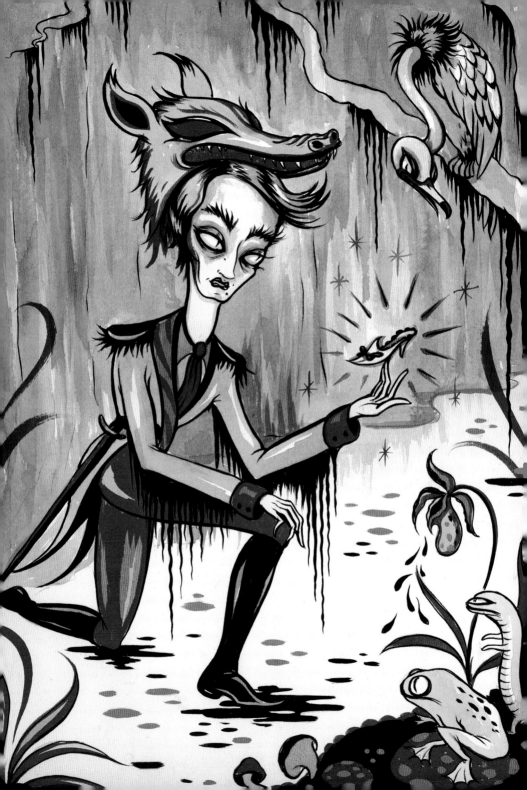

The prince

followed her, but could not overtake her. As she ran, one of her glass slippers fell off—although the prince later found it and carefully picked it up for safekeeping.

Unable to find her, the prince asked the guards at the gate if they had seen a princess of Cinderella's description pass by. They answered that they had seen no one except for a poorly dressed girl, who had more the appearance of a peasant than of a fine lady.

inderella ran all the way home, without coach or footman, arriving almost breathless, dressed in her shabby clothes. Nothing remained of her finery but one of her little glass slippers.

When the two sisters returned from the ball, Cinderella asked whether they had been as much entertained as before, and if the beautiful princess had been present again. They said she had, but that she had fled as soon as the clock struck twelve and in her haste had dropped one of her tiny glass slippers, the prettiest in the world.

They said that the prince had picked up her shoe and had done nothing but gaze upon it during the remainder of the evening. Undoubtedly, he was very much in love with the lady to whom the slipper belonged.

The sisters spoke the truth; for only a few days later, a herald of the king proclaimed—accompanied by trumpet fanfare—that

the prince
would marry
the woman
whose foot fit
the slipper
exactly.

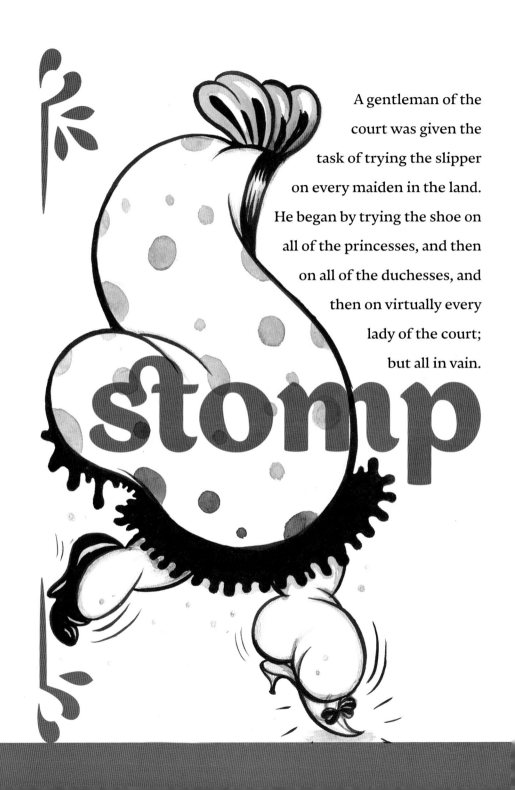

A gentleman of the court was given the task of trying the slipper on every maiden in the land. He began by trying the shoe on all of the princesses, and then on all of the duchesses, and then on virtually every lady of the court; but all in vain.

stomp

When he arrived
at the nobleman's
home, he presented
the shoe to Cinderella's
stepsisters. Although
both girls did their
utmost to force a foot
into the dainty slipper, they
could not manage to
do so.

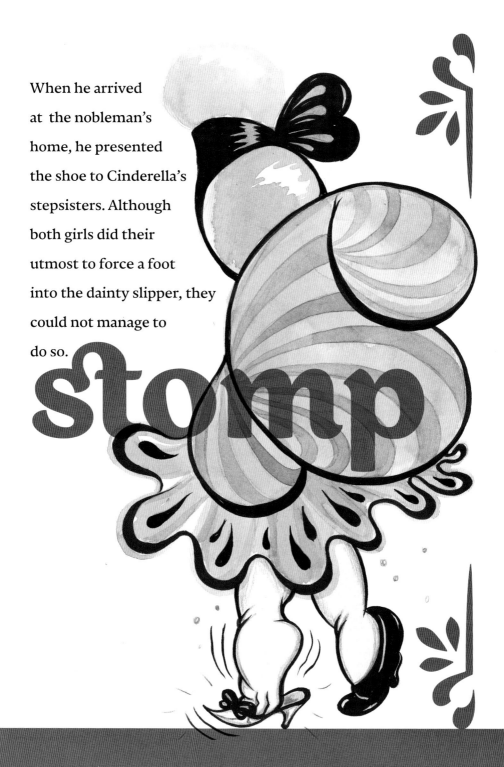

stomp

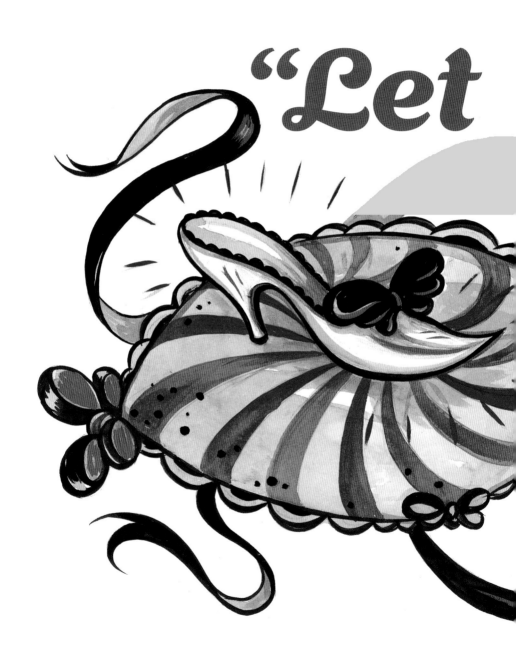

"*Let*

Cinderella, who was looking on at the spectacle, said with a little laugh,

me see *if it* will not *fit me.*"

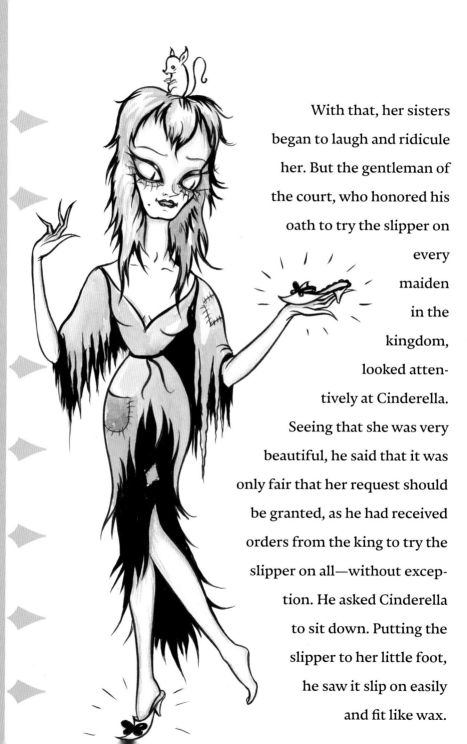

With that, her sisters began to laugh and ridicule her. But the gentleman of the court, who honored his oath to try the slipper on every maiden in the kingdom, looked attentively at Cinderella. Seeing that she was very beautiful, he said that it was only fair that her request should be granted, as he had received orders from the king to try the slipper on all—without exception. He asked Cinderella to sit down. Putting the slipper to her little foot, he saw it slip on easily and fit like wax.

The two sisters were greatly
astonished, but even more so when

Cinderella took the other slipper out of her pocket and put it on her other foot.

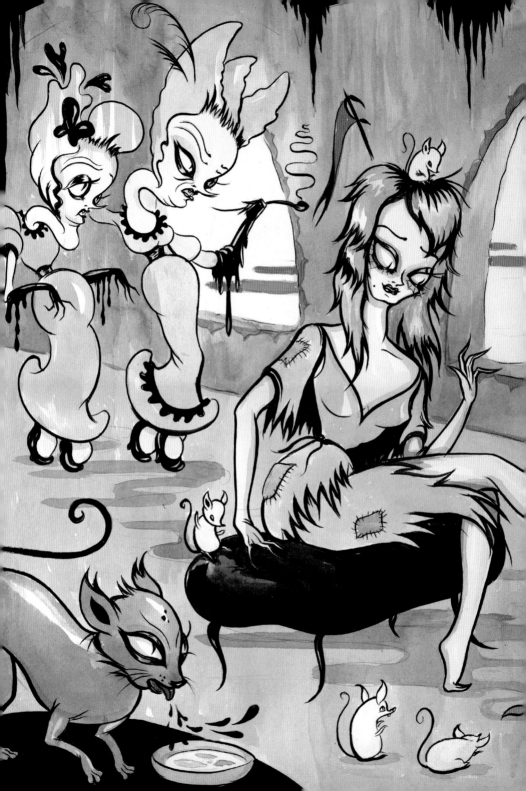

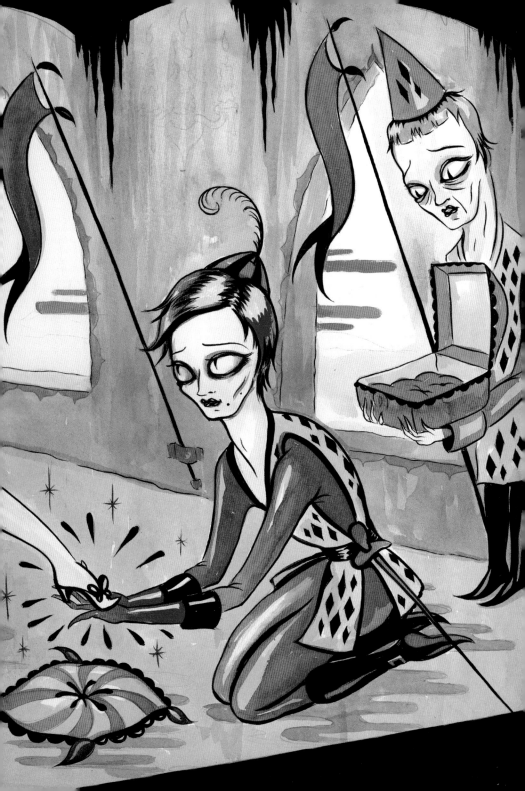

At that very moment Cinderella's fairy godmother appeared. She tapped her wand to Cinderella's rags, and they became still more magnificent than those she had worn to the balls.

The two sisters then understood that Cinderella was the beautiful princess who had caused such excitement the last two evenings. They threw themselves at her feet, begging for forgiveness for all the ill treatment she had suffered from them. Cinderella raised

EVERYONE LIVED

hap

ever

and embraced them, saying that she forgave them with all her heart and implored them to love her dearly in the future.

Cinderella was then conducted, dressed as she was, to the young prince. He found her more charming than ever, and a few days afterward he married her. And Cinderella, who was as kind as she was beautiful, gave her sisters apartments in the palace, and married them the very same day to two fine lords of the court.

pily after.

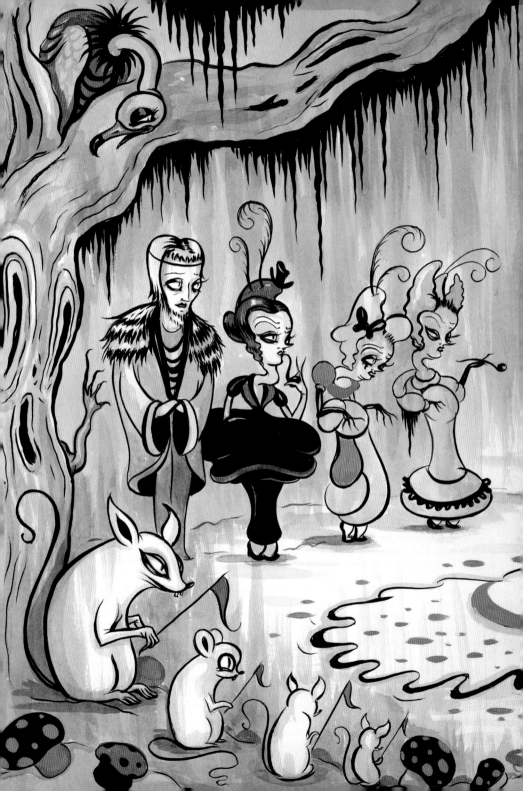

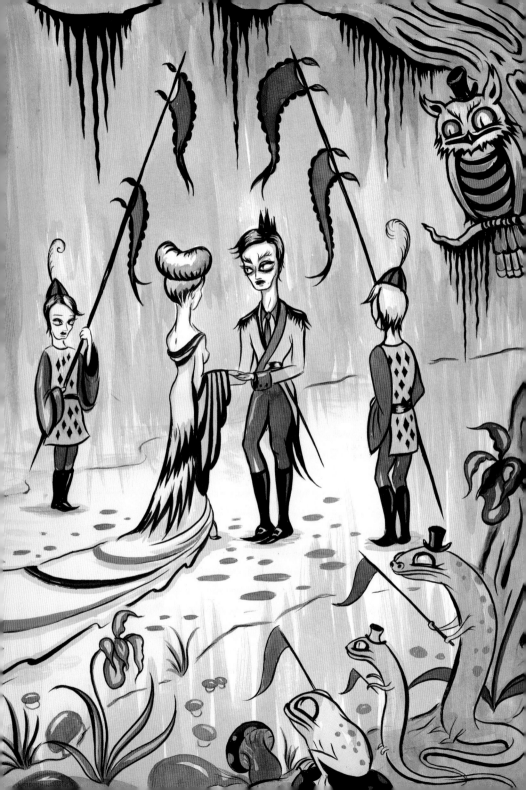

Beauty in woman is a treasure rare

Which we are never weary of admiring;

But a sweet temper is a gift more fair

And better worth the youthful maid's desiring.

That was the boon bestowed on Cinderella

By her wise godmother—her truest glory.

The rest was "nought but leather and prunella."

Such is the moral of this little story—

Beauties that charm become you more than dress,

And win a heart with far greater facility.

In short, in all things to ensure success,

The real Fairy Gift is amiability!

Talent, courage, wit, and worth

Are rare gifts to own on earth;

But if you want to thrive at court—

So, at least, the wise report—

You will find you need some others,

Such as godfathers or mothers.

Cinderella, or The Little Glass Slipper by CHARLES PERRAULT

Text copyright © 2015 HARPER DESIGN

Illustrations copyright © 2015 CAMILLE ROSE GARCIA

HarperCollins books may be purchased for educational, business, or sales promotional use. For information please e-mail the Special Markets Department at SPsales@harpercollins.com.

First published in 2015 by
Harper Design
An Imprint of
HarperCollins*Publishers*
195 Broadway
New York, NY 10007
Tel: (212) 207-7000
Fax: (855) 746-6023
harperdesign@harpercollins.com
www.hc.com

Distributed throughout the world
by HarperCollins*Publishers*
195 Broadway
New York, NY 10007
Fax: (855) 746-6023

ISBN 978-0-06-233391-9

Library of Congress Control
Number: 2013953418

Book design by
Roberto de Vicq de Cumptich
www.devicq.com

Display font was set in Pelikan by
Roberto de Vicq de Cumptich and
text in Nocturno by Nikola Djurek

Printed in China

First printing, 2015